PB
Ex cat
18 03

The Brown Sisters

Nicholas Nixon The Brown Sisters

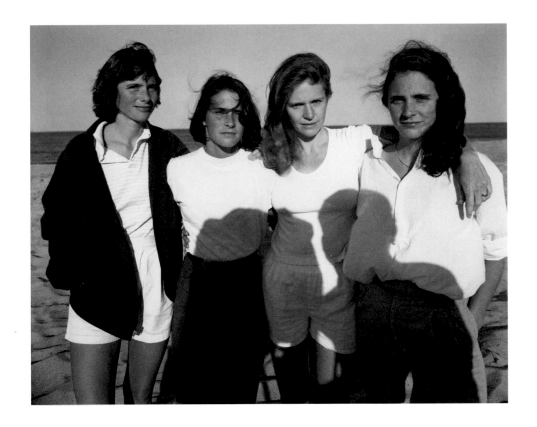

The Museum of Modern Art, New York

Distributed by Harry N. Abrams, Inc., New York

This book is made possible by the generous
support of CameraWorks, Inc., the John Szarkowski
Publications Fund, and The Contemporary Arts Council and
The Junior Associates of The Museum of Modern Art.

Produced by the Department of Publications
The Museum of Modern Art, New York

Edited by Joanne Greenspun
Designed by Gina Rossi
Production by Marc Sapir
Set in Bembo VAL and Minion
Printed on Aberdeen Silk by Stamperia Valdonega,
S.R.L., Verona

Library of Congress Catalogue Card Number: 99–74592
ISBN 0-87070-042-1 (MoMA)
ISBN 0-8109-6200-4 (Abrams)

Published by The Museum of Modern Art
11 West 53 Street, New York, New York 10019
Distributed in the United States and Canada by
Harry N. Abrams, Inc., New York
Distributed outside the U.S. and Canada by Thames
and Hudson, Ltd., London

Cover: Nicholas Nixon. *The Brown Sisters*. 1984

Printed in Italy

To Sally and Fred Brown,
parents of Bebe, Heather, Laurie, and Mimi

There are four people I would like to thank: the Brown sisters them-selves. These pictures grew out of my curiosity about and admira-tion for this band of beautiful, strong women, who first let me into their lives, then allowed me to try making one picture, then joined me in a tradition, an annual rite of passage. I love my sisters-in-law Mimi, Laurie, and Heather, and I thank them wholeheartedly for their love and patience. Bebe, my true love, my best friend, is the center of my life. How lucky, how grateful I am.

Nicholas Nixon

1975

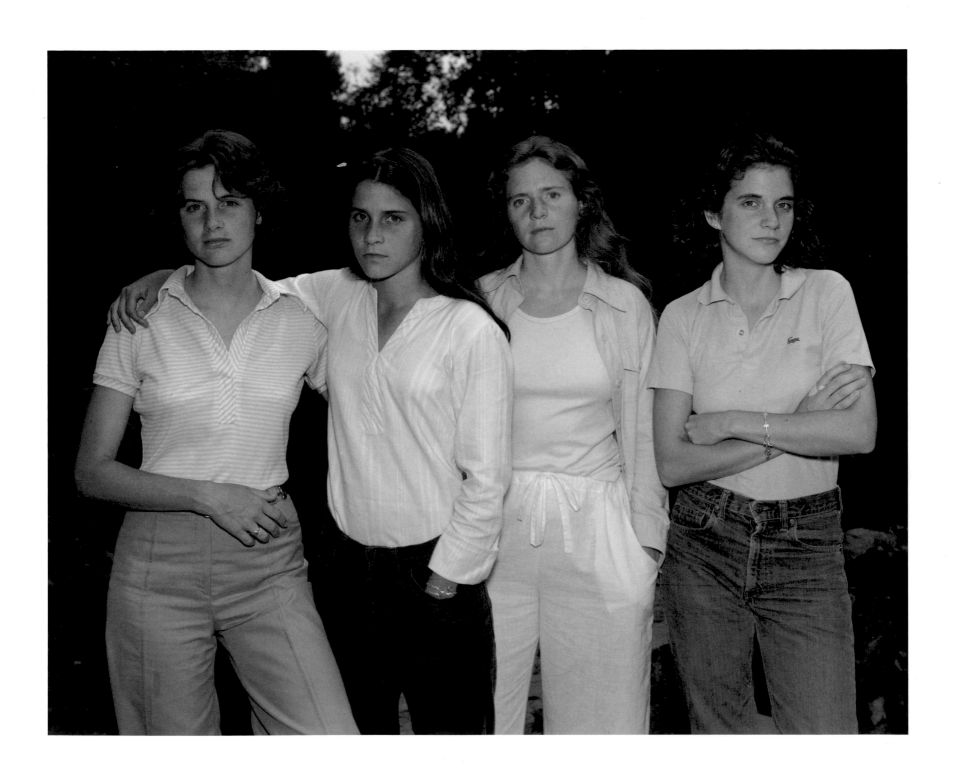

1976

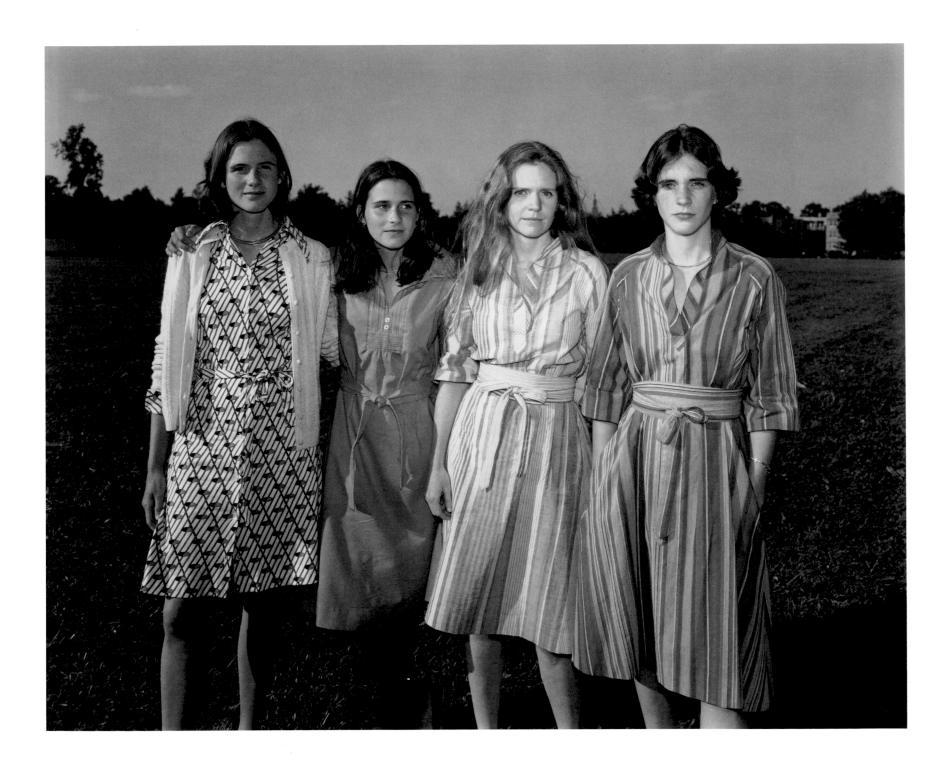

1977

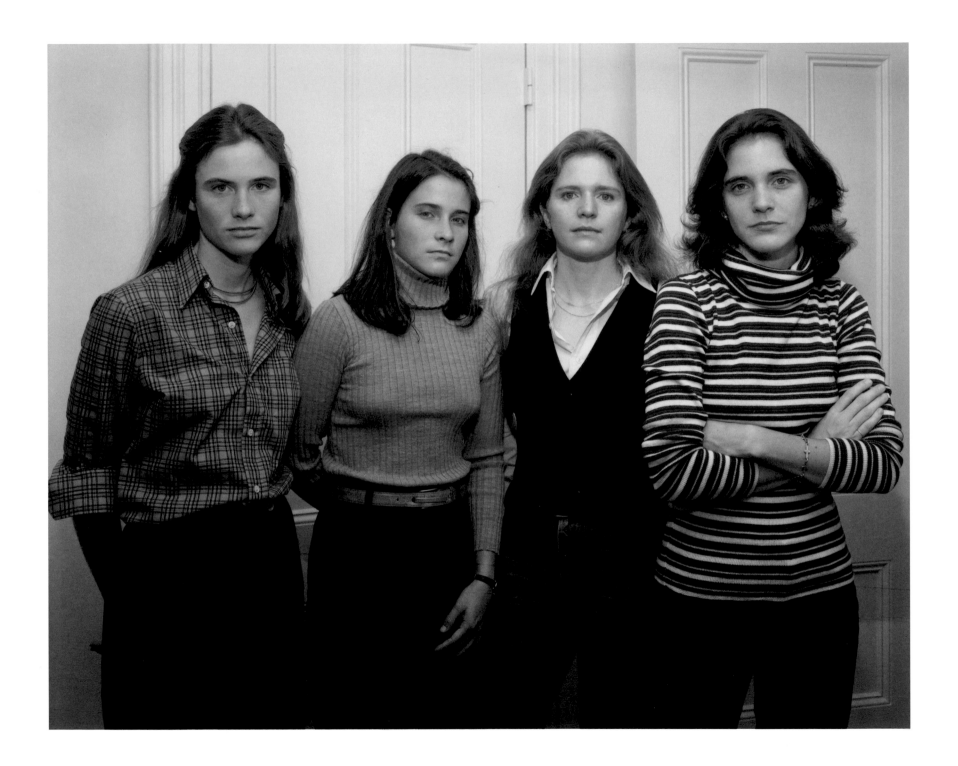

1978

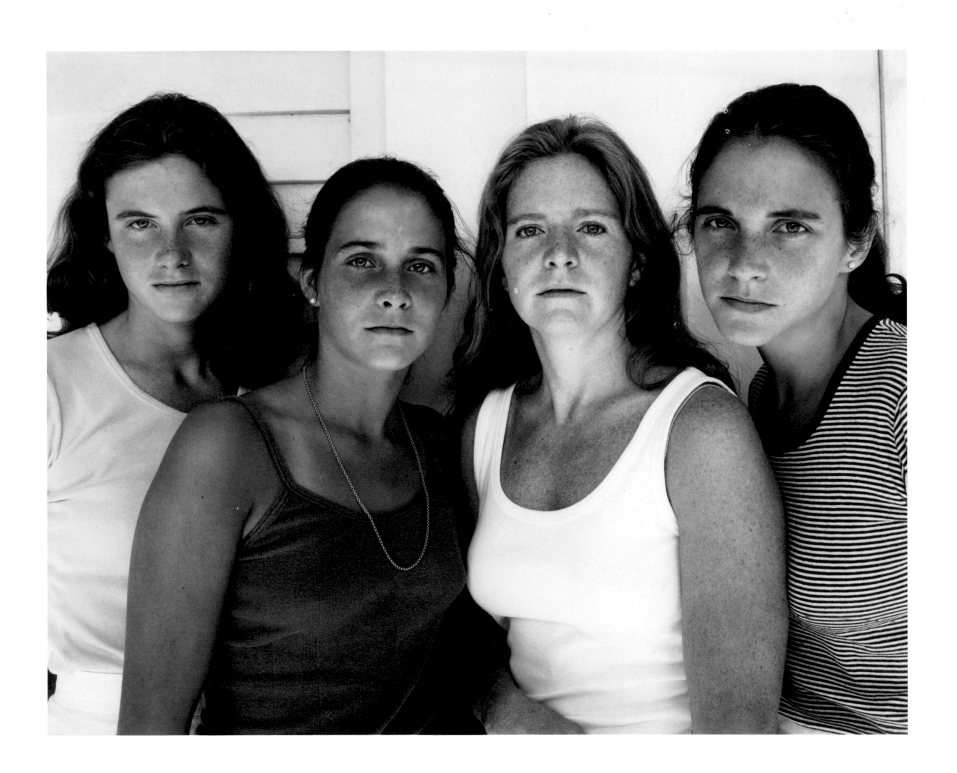

1979

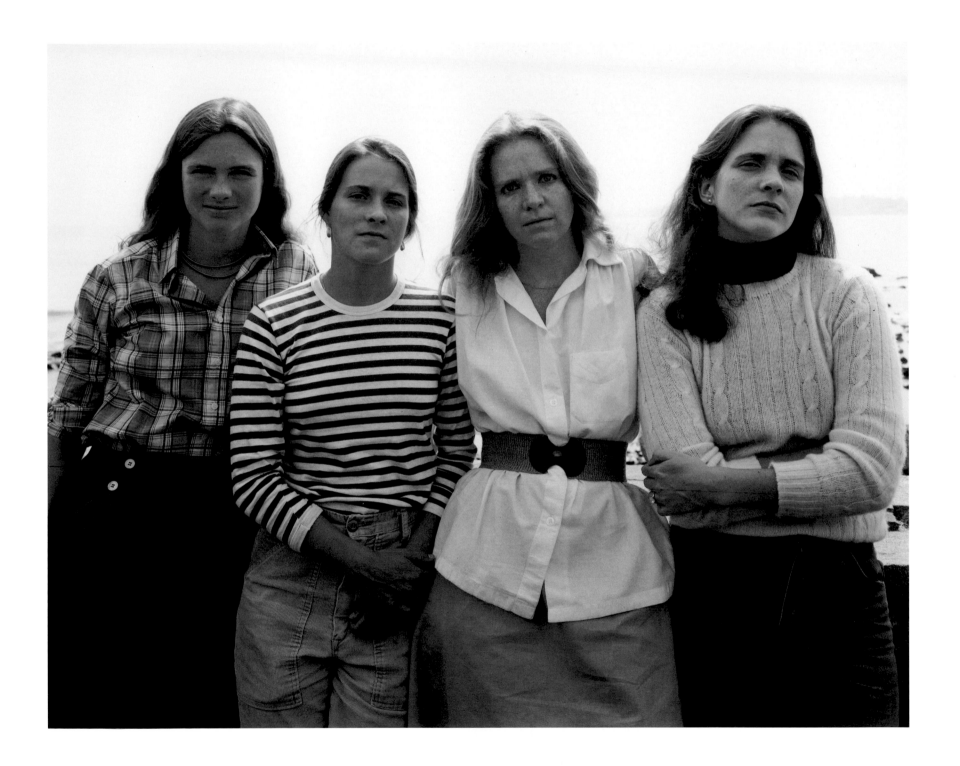

1980

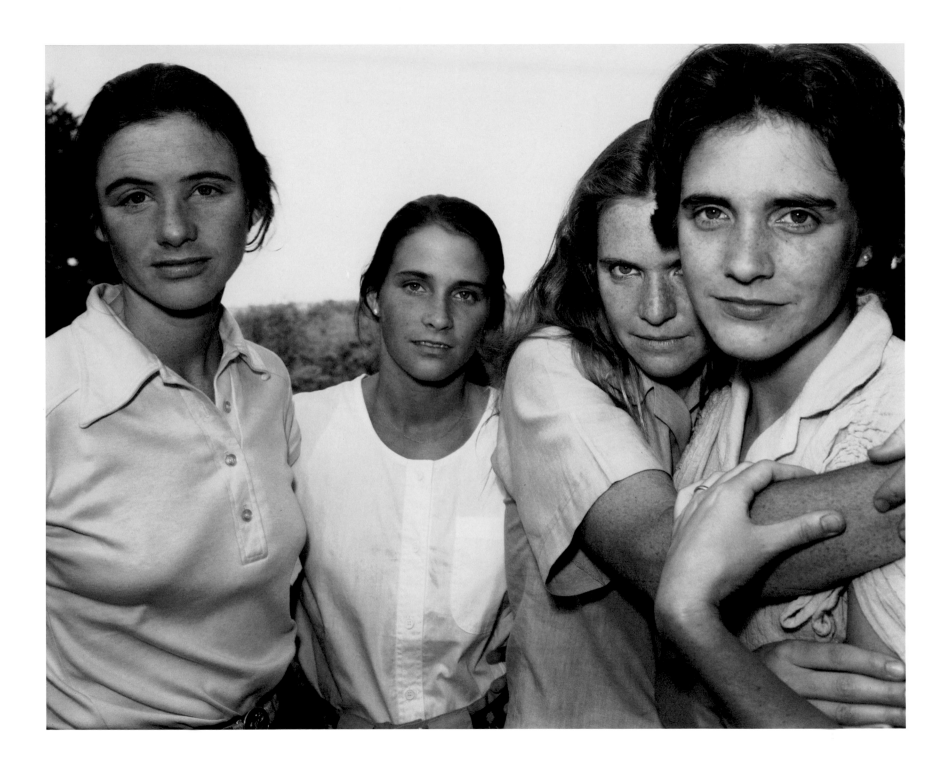

1981

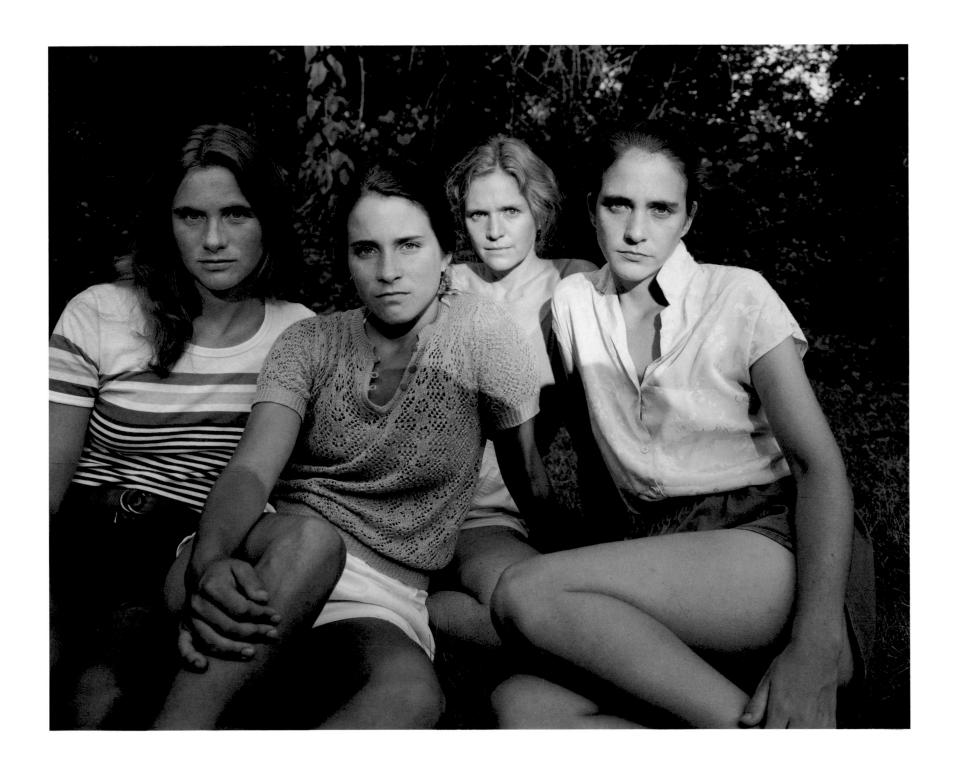

1982

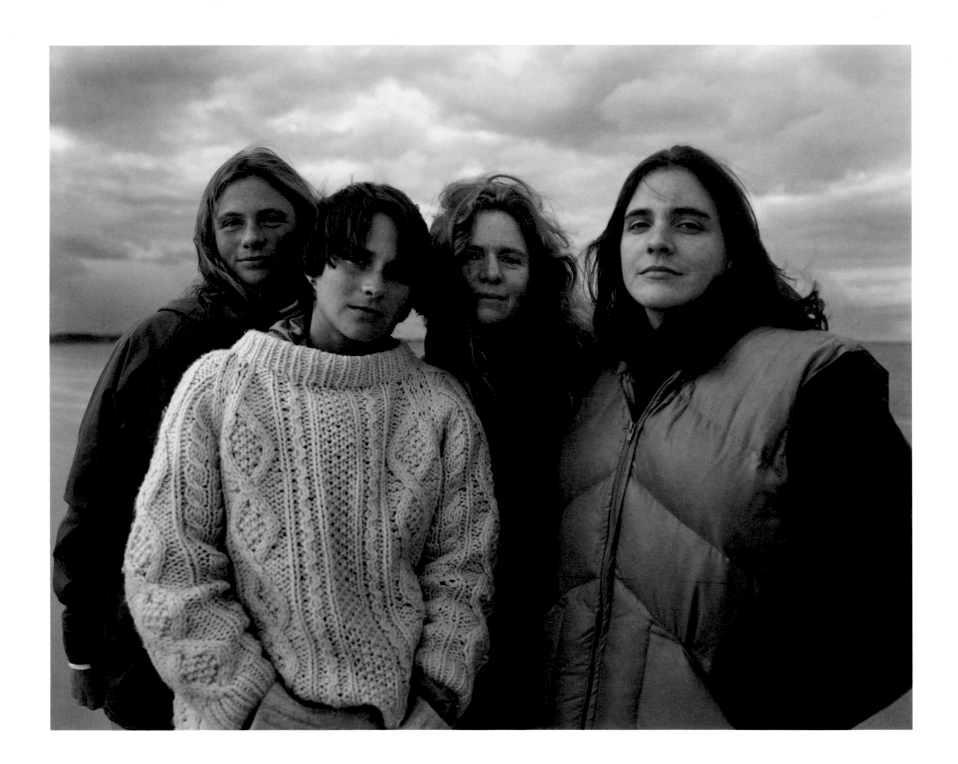

1984

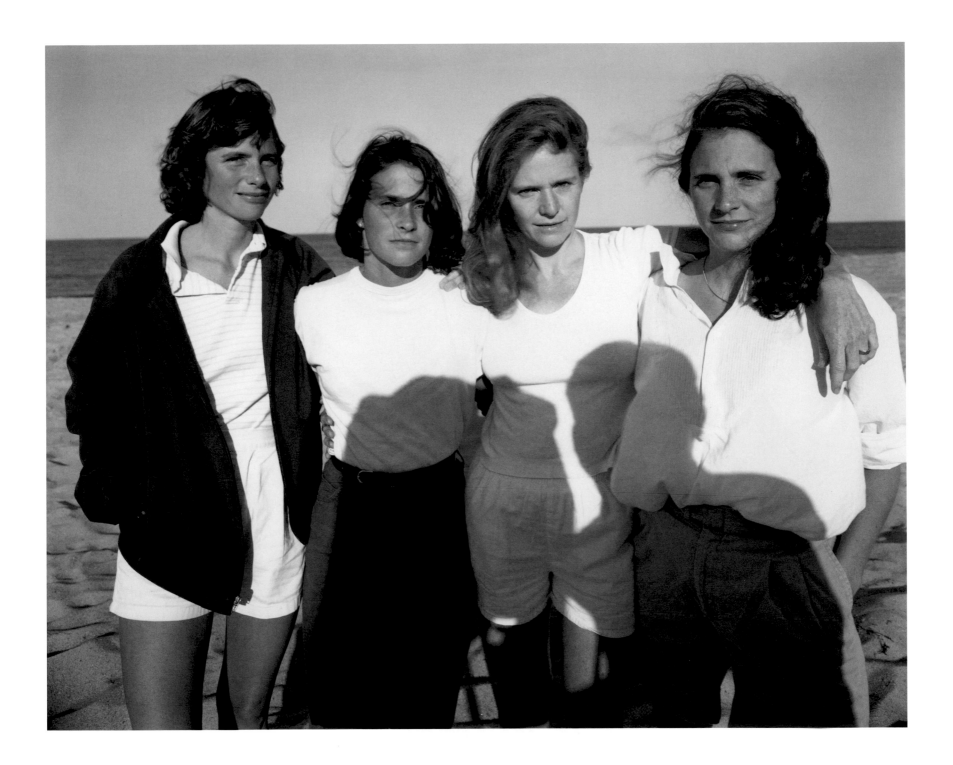

1985

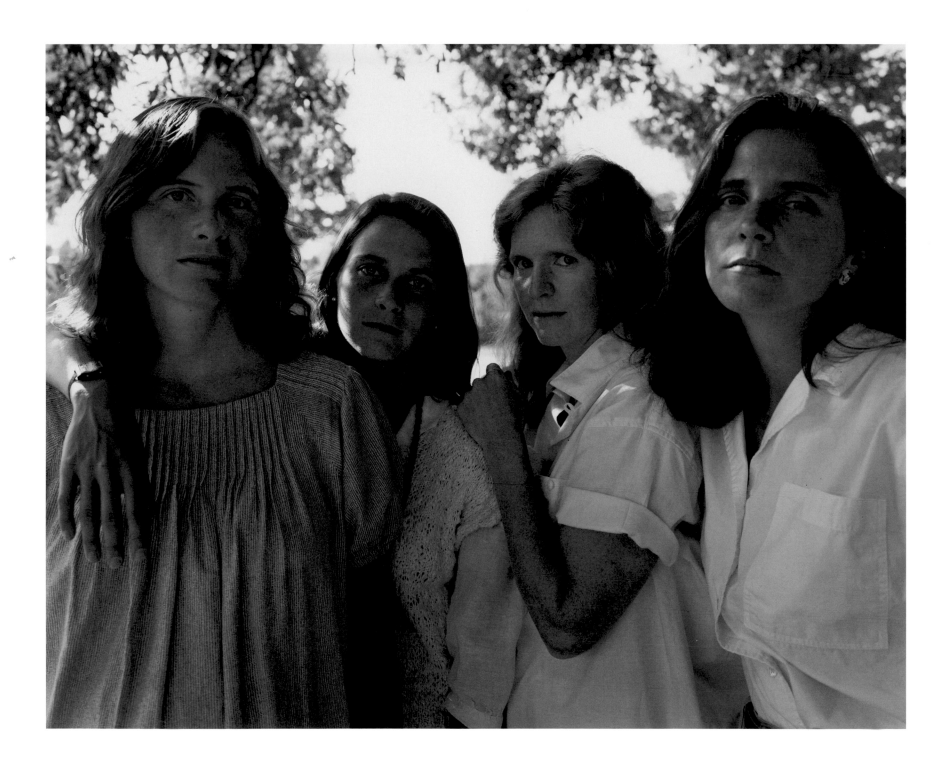

1986

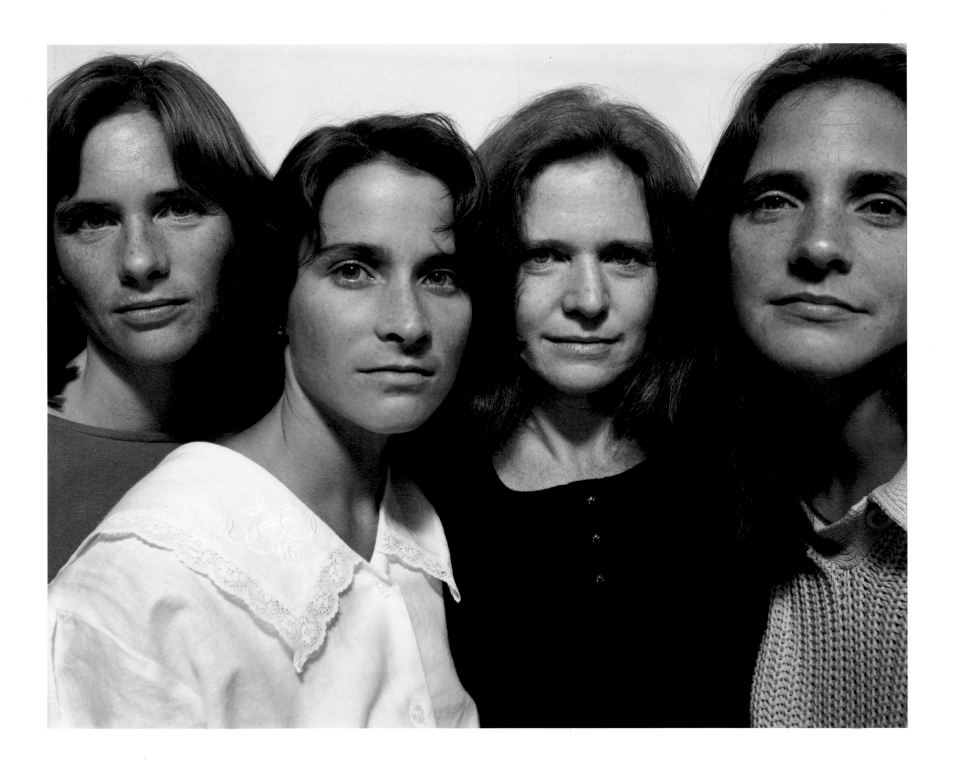

1987

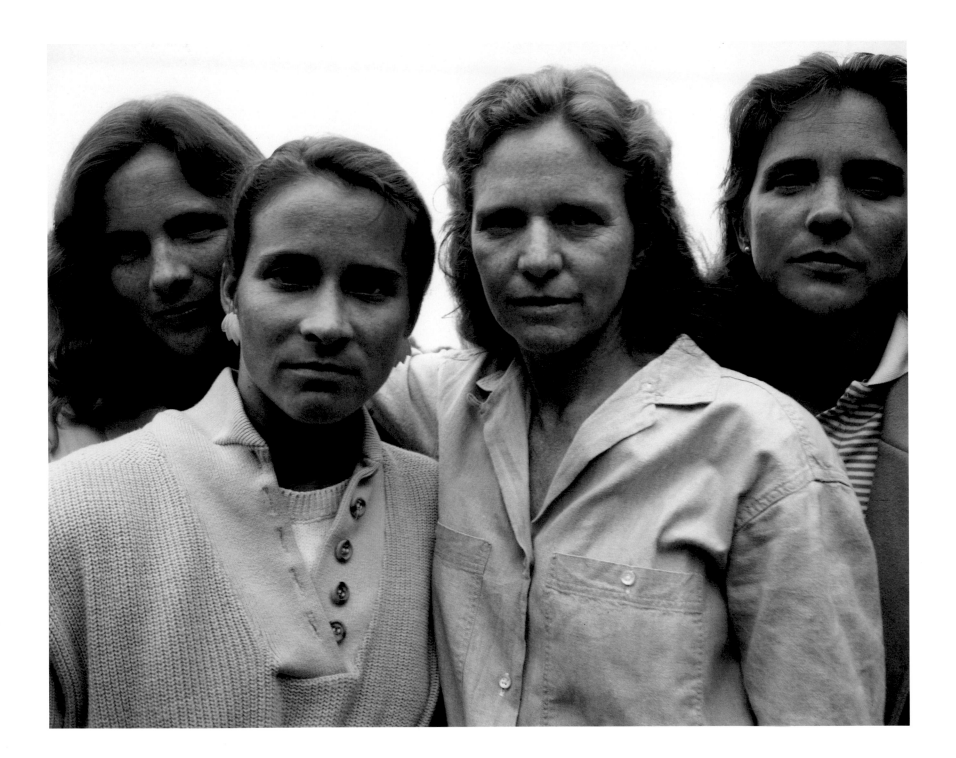

1988

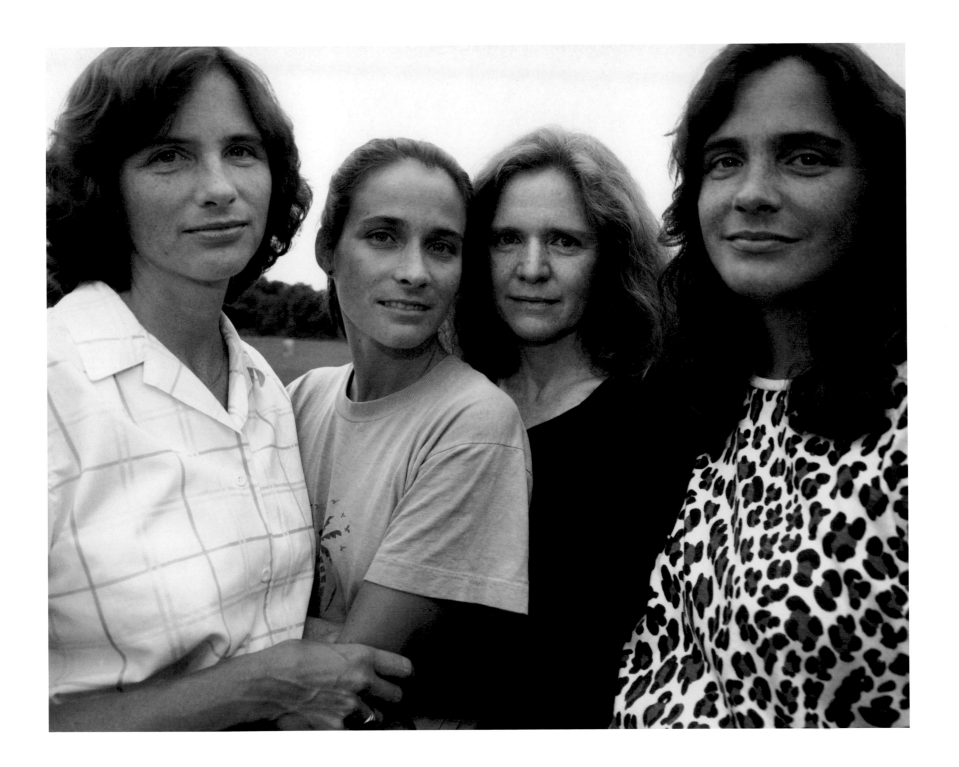

1989

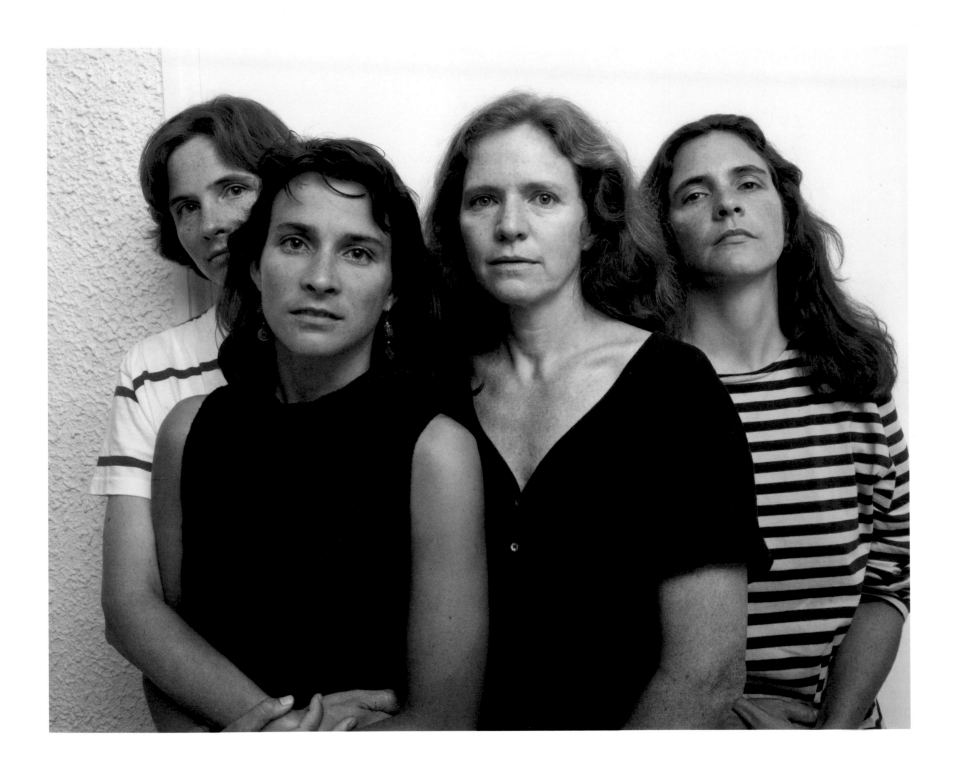

1990

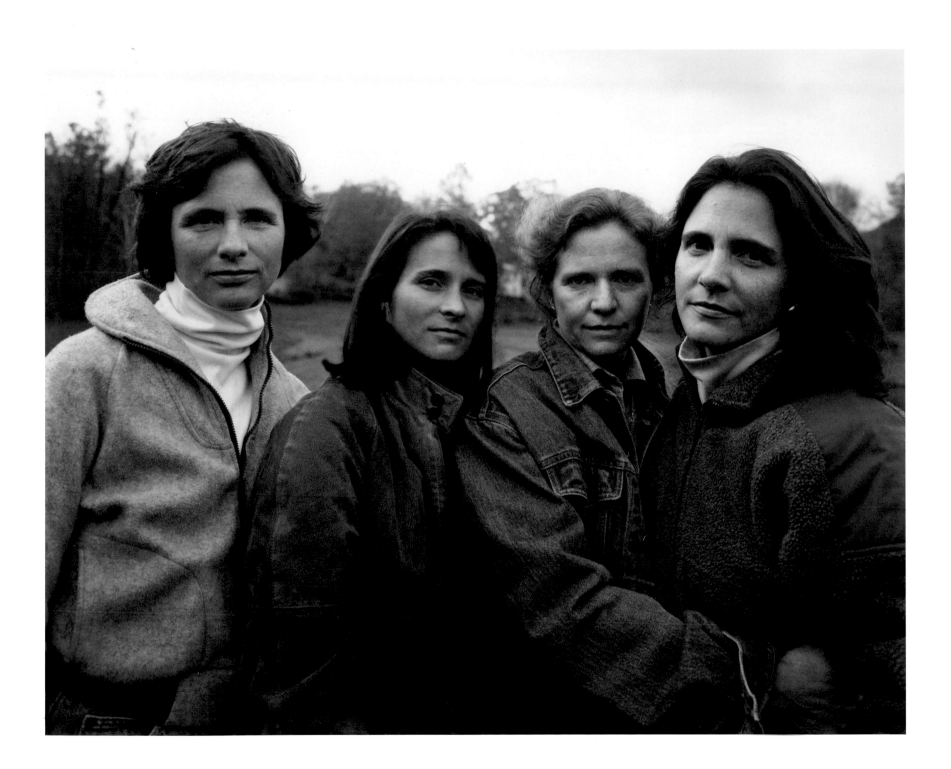

1991

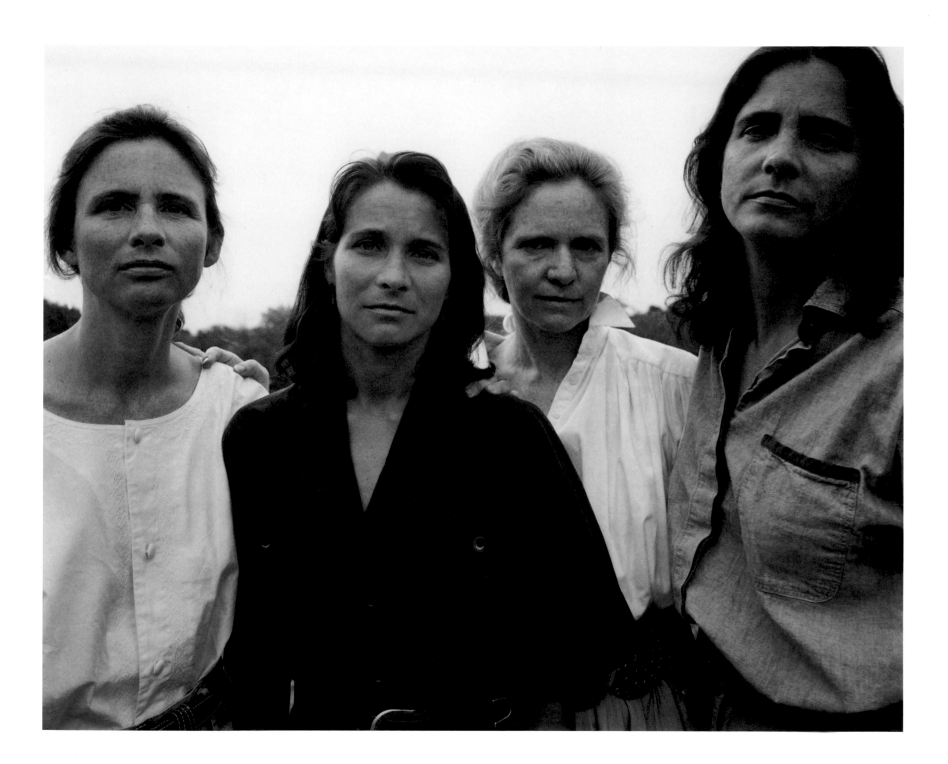

1992

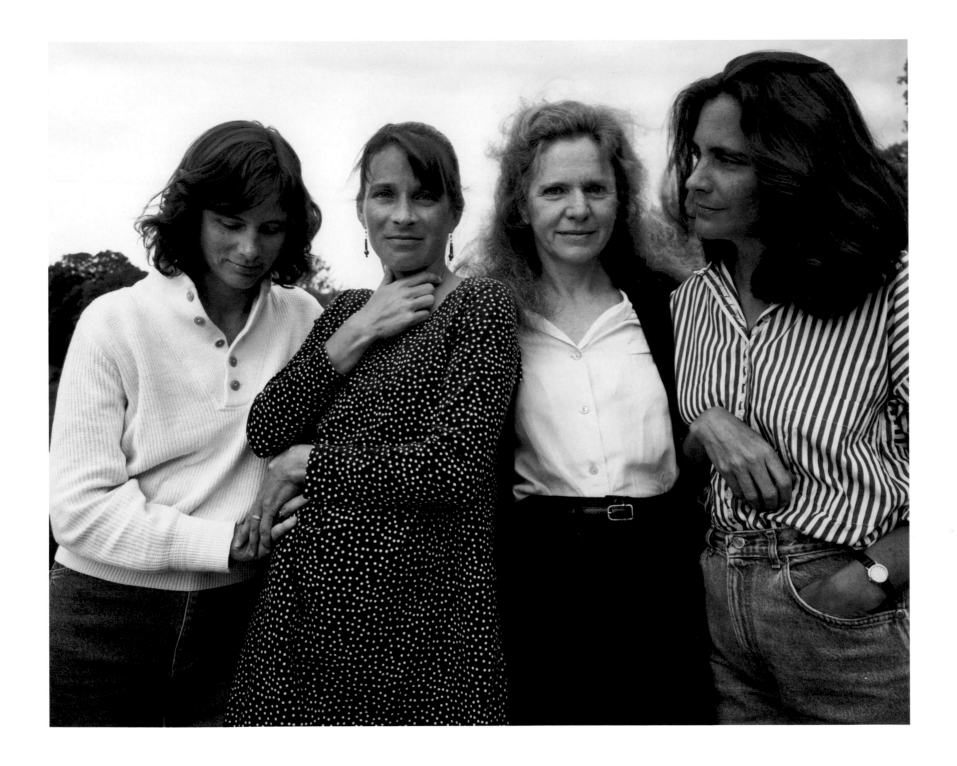

1993

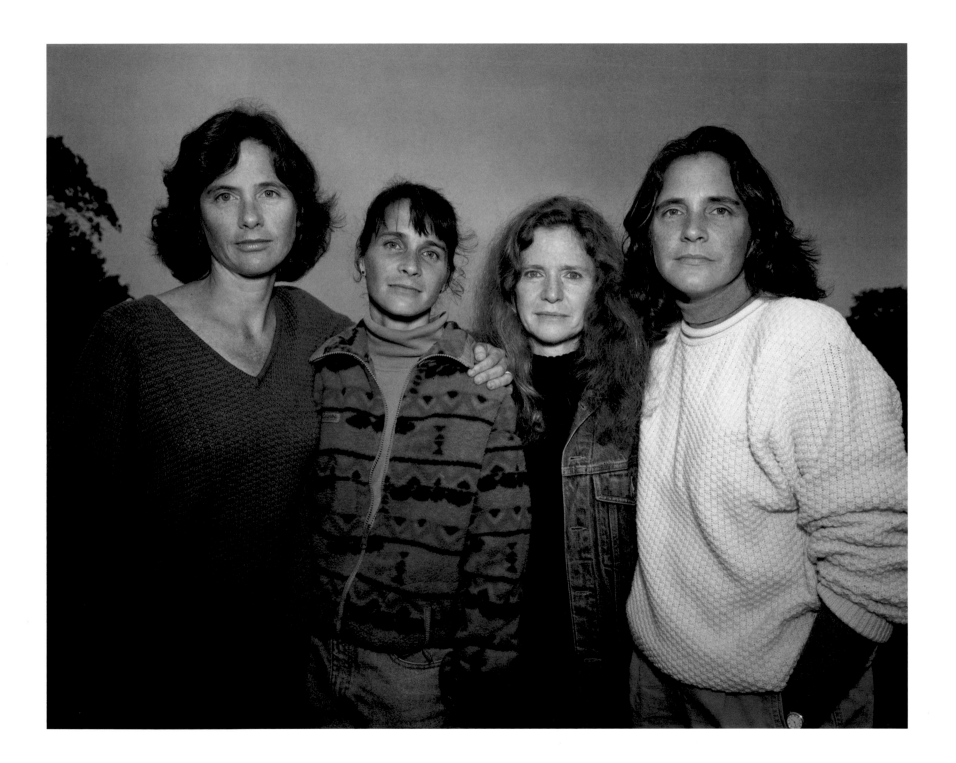

1994

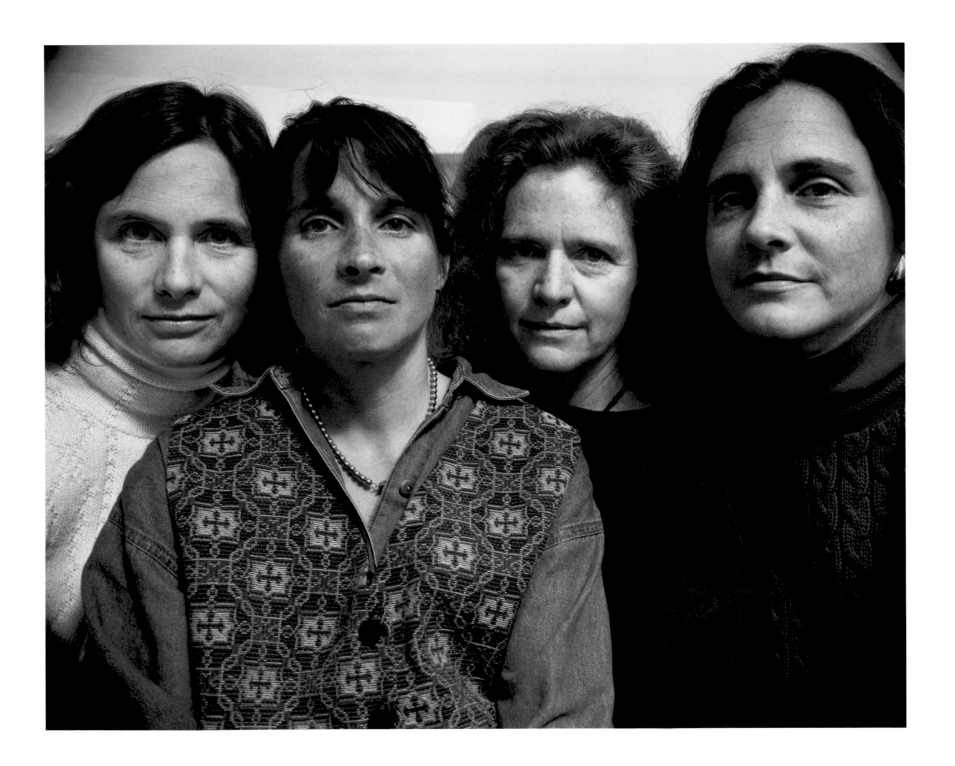

1995

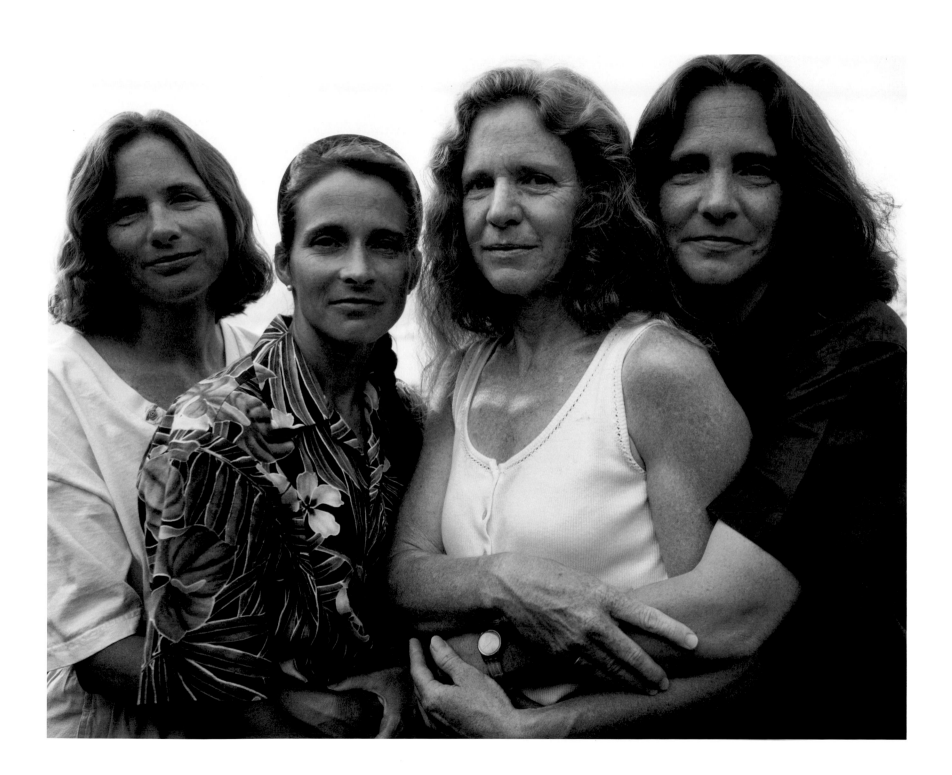

1996

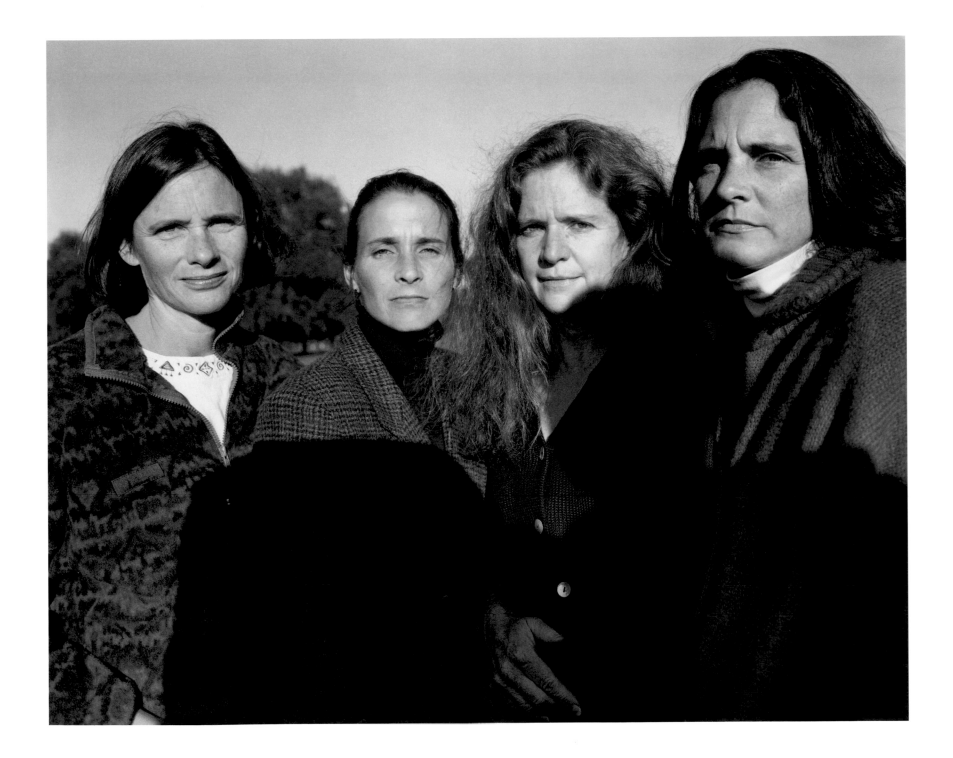

1997

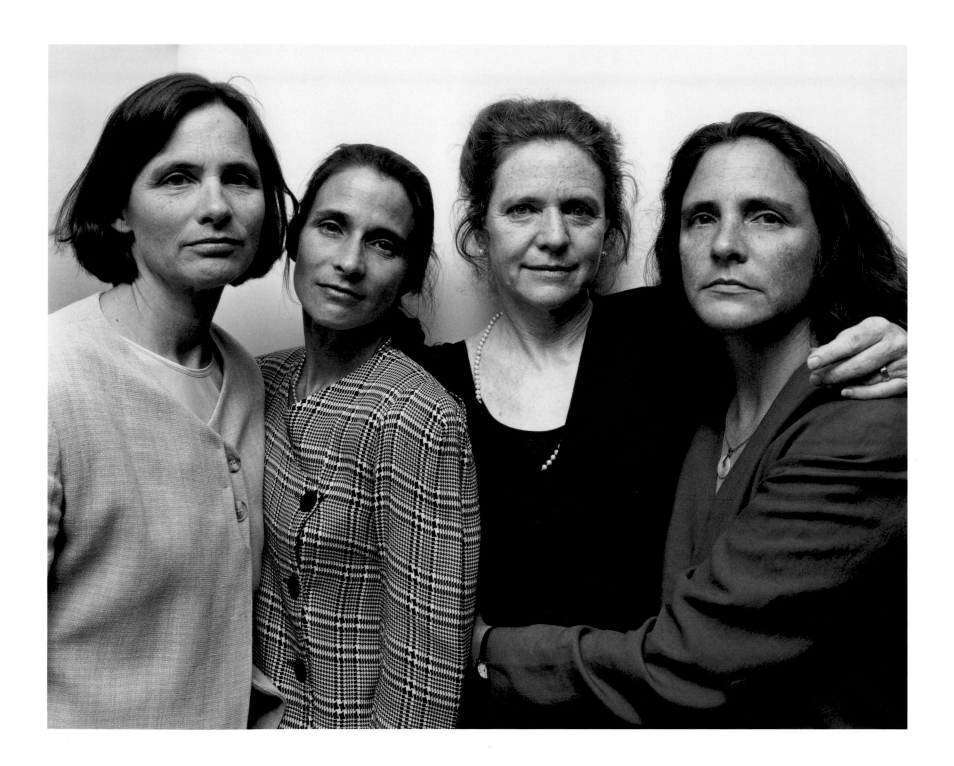

1998

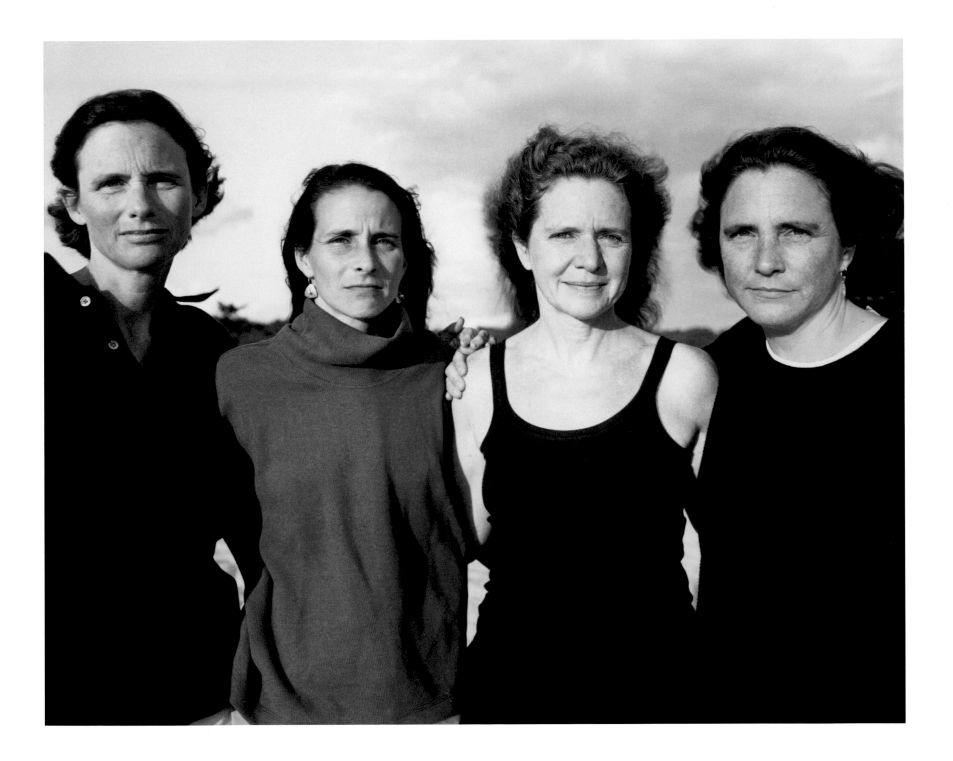

1999

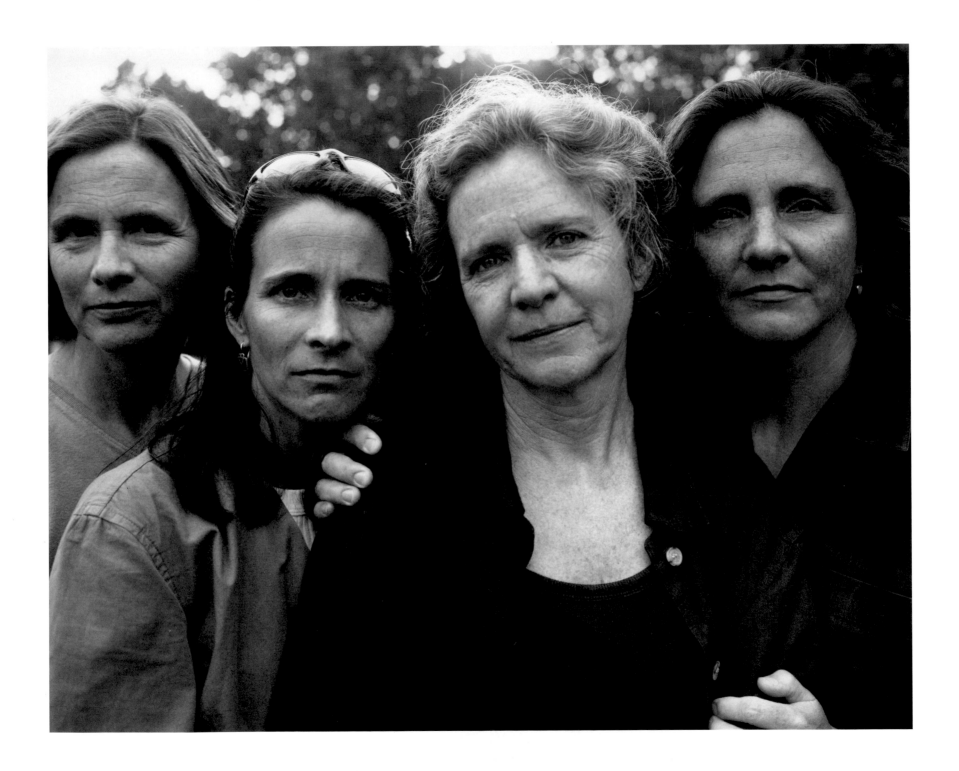

Nicholas Nixon (Nick) met Beverly Brown (Bebe) in June 1970. He was twenty-two years old; she was twenty. They were married in June 1971, shortly after Bebe graduated from college. After living in Minneapolis, then in Albuquerque, where Nick earned a Master of Fine Arts degree in photography at the University of New Mexico, the couple moved near to Boston in July 1974.

The move coincided with Nick's decision to work exclusively with an eight-by-ten-inch view camera. For a generation or more, advanced photographers had favored small, handheld cameras, like the ones we all use to make snapshots. The big eight-by-ten-inch camera (its hulking shadow appears in the 1984 portrait of the Brown sisters) is much more cumbersome, but its large negatives capture a wealth of precise detail and a luscious continuity of tone. When these negatives are printed by contact, producing a print of the same size, none of the visual information they carry is diluted by enlargement. Nixon's work of the 1970s helped to lead a revival of large-camera photography and its aesthetic of crisp, luxurious description.

Bebe has three sisters. Nick is the only child of two only children, so the frequent large Brown family gatherings were a new experience for him. Also new was the collection of annual Christmas-card snapshots of their children that Sally and Fred Brown, parents of the four sisters, had been sending to family and friends since the birth of Bebe, their eldest. The entire series of snapshots—there are now forty-nine—is on permanent exhibition in the Brown home, where Sally and Fred celebrated their fiftieth wedding anniversary in 1997.

At a Brown family get-together in August 1974, Nick made a portrait of the four sisters. He soon decided that the photograph was a failure and discarded the negative. In July 1975 he made a second group portrait—the first picture in this book. At the time, Bebe was twenty-five. Her sisters Heather, Laurie, and Mimi were

twenty-three, twenty-one, and fifteen, respectively. Nick liked the picture and kept it. When Laurie graduated from college the following June, the family gathered again and Nick made another picture of the sisters. It was this second successful portrait that prompted Nick to suggest to the four women that they assemble for one picture every year. (In fact, he makes a dozen or more negatives on each occasion, then chooses a single one to represent that year.) They decided, too, that the order in which they appeared would always be the same: from left to right, Heather, Mimi, Bebe, and Laurie. In the summer of 1999, the five participants performed this annual ritual for the twenty-fifth time.

Rarely has so absorbing a work of art been so little in need of commentary. The Brown sisters face the camera just as our siblings and parents and grandparents and children and in-laws do in our own family pictures. We might wish that we had made our photographs as regu-larly, and that our family included a photographer of such discipline and skill. And we ought to marvel at the candor and perseverance of the four women, who have sustained the project year after year, even after they knew that their essentially private portraits were likely to show up publicly, in books and on the walls of museums. But otherwise Nixon's pictures do what all family photographs do: they fix a presence and mark the passage of time, graciously declining to expound or explain.

Or perhaps that is not quite true. Perhaps the obvious similarity between Nixon's series and our family photographs invites us to discount a crucial difference. We bring worlds of knowledge and feeling to our own snapshots, but we know next to nothing about the Brown sisters. The depth of Nixon's mute allusion to the living of four linked lives rests on the alertness and delicacy of his attention.

Peter Galassi

Nicholas Nixon is American, born in 1947.

The photographs are gelatin silver prints.
Each measures $7^{11}/_{16} \times 9^{11}/_{16}$" (19.6 × 24.6 cm).
All are in the collection of The Museum of
Modern Art, and were acquired as follows:

1975, 1979, 1982, 1984, 1985, 1990,
1993, 1997, 1999:
Gift of the photographer

1976, 1991:
Purchase

1977, 1978, 1987:
John Parkinson III Fund

1980:
Gift of Pierre N. Leval

1981, 1983:
David H. McAlpin Fund

1986, 1994, 1998:
Lois and Bruce Zenkel Fund

1988, 1989, 1995, 1996:
The Family of Man Fund

1992:
Geraldine J. Murphy Fund

Books of photographs by Nicholas Nixon

Photographs from One Year. Number 31 of the periodical *Untitled*. Introduction by Robert Adams. Carmel, California: The Friends of Photography, in association with The Institute of Contemporary Art, Boston, 1983.

Pictures of People. Introduction by Peter Galassi. Exhibition catalogue. New York: The Museum of Modern Art, 1988.

People with AIDS. Text by Bebe Nixon. Boston: David R. Godine, 1991.

Family Pictures. In the series "Photographers at Work." Washington and London: Smithsonian Institution Press, in association with Constance Sullivan Editions, 1991.

Familienbilder. Essay by Thomas Weski. Exhibition catalogue. Hannover, Germany: Sprengel-Museum, 1994.

School. Text by Robert Coles. Boston: Little, Brown, 1998.